# KÄTHE KOLLWITZ

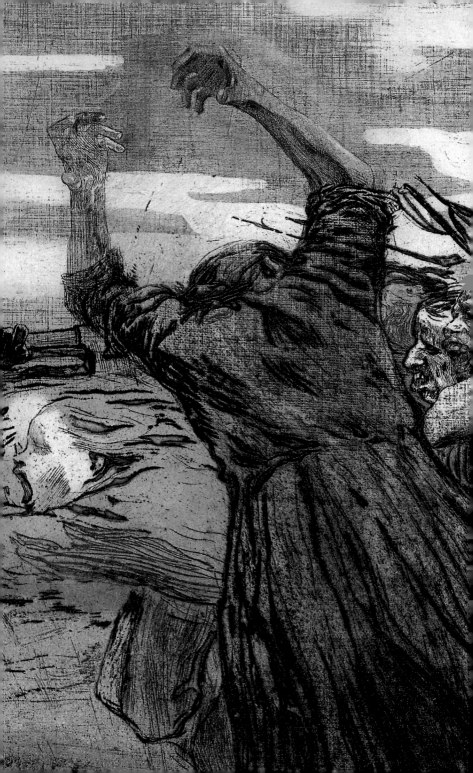

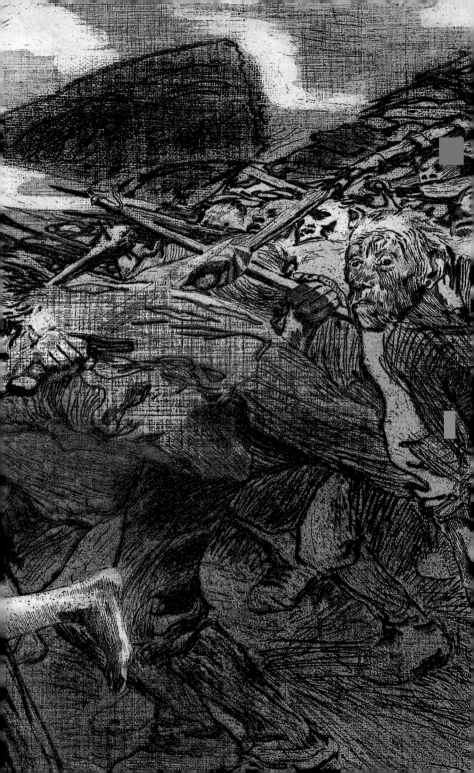

# KÄTHE
# KOLLWITZ

Josephine Gabler
Käthe-Kollwitz-Museum Berlin

**HIRMER**

**KÄTHE KOLLWITZ**
*Self-Portrait en face, laughing,* ca.1888–89
Pen and brush drawing

# CONTENTS

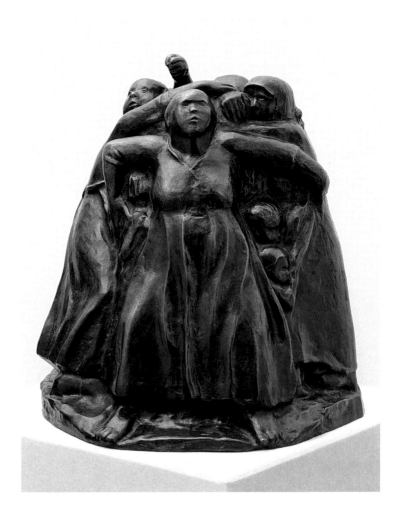

1  *Tower of Mothers*, 1937/38, bronze

# KÄTHE KOLLWITZ –
# THE VISIBLE WOMAN ARTIST

Josephine Gabler

For the era around 1900 Käthe Kollwitz's artistic life proceeded rather un-
usually in many respects. Her family supported her choice of profession;
she grew up in a liberal, politically-active household; she earned recogni-
tion as a woman in the art world; and she resonates with people in the
twenty-first century with a style of art that is figurative and uses no colour.
Kollwitz created an oeuvre that does not need to be explained, but that
'speaks' intelligibly via the invented image – like her poster *Never Again
War* (2), for example, which is once again so terribly relevant. This power-
ful visual invention vehemently articulates an appeal against war that has
been understood by people for 100 years.

## KÖNIGSBERG – BERLIN – MUNICH

Käthe Kollwitz was born Käthe Schmidt in Königsberg in East Prussia – pre-
sent-day Kaliningrad in Russia – in 1867. She had an older brother, Konrad,
and two sisters, the elder Julie and the younger Lisbeth. The family was
strongly influenced by her grandfather Julius Rupp (1809–1884), who had
studied theology and philosophy in Königsberg and had earned his post-
doctoral lecture qualification there. For a time he taught as a private lec-
turer at Königsberg University. Rupp had to give up his post as pastor of

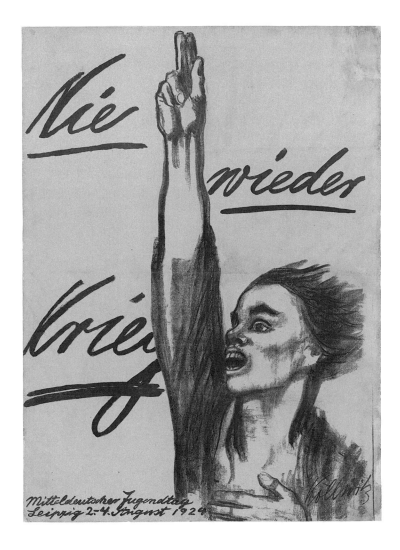

2 *Never Again War*, 1924, lithograph

the garrison in Königsberg in 1845 after conflicts with the Prussian church administration; he then founded a Free Protestant church congregation, over which he presided for a long time. After the revolution of 1848, he became a member of the Prussian House of Representatives and joined the Progressive Party.

Käthe's father, Carl Schmidt (1825–1898), had lost his parents at an early age and had struggled to study law under difficult conditions. However, because of his affiliation with the Free Protestant congregation of his future father-in-law and his liberal political views, he was dismissed from his judicial clerkship and had to abandon his legal training. He then learned the bricklaying trade and set up his own business as a building contractor. He sold the successful business around 1880 and afterwards concentrated on his work in the Free Protestant church community, which he took over from Julius Rupp in 1884.[1]

According to the descriptions of the two younger daughters Käthe and Lisbeth, the children had a carefree and intellectually stimulating childhood in Königsberg. In 1923 Käthe recalled that 'the parents followed the method of giving us opportunities for further development without thumbing their noses at us. For example, the bookcase was open to us children and they did not supervise what we took from it. They were all good books too. I read Schiller in a large beautiful edition with engravings by Kaulbach, and I read Goethe. Goethe took root in me very early. I never left him for the rest of my life.'[2]

Käthe's brother Konrad later studied economics and philosophy in Berlin, earned his doctorate in Königsberg and actively corresponded with Friedrich Engels in London. He settled in Berlin and worked primarily as a journalist. Father and son both joined the SPD (Social Democratic Party) at the end of the 1880s.

The three sisters were educated privately, and only the middle daughter Käthe seems to have been expected to work. Julie married at the age of 21 and moved to Berlin in 1886. The youngest of the sisters – Lisbeth, with whom Käthe had the closest contact throughout her life – followed Julie to the imperial capital in 1893 at the age of 23. She married the Königsberg physicist Georg Stern, who soon made a career in the electrical industry as a high-voltage engineer.

Käthe, however, was to be trained as an artist because of her interest and talent. From the age of 14 she received drawing lessons from Rudolf Mauer

(1845–1905), who also taught at the Königsberg Academy. Her training was supplemented by lessons from the young painter Gustav Naujok (1861–?). Subsequently, she pursued regular studies at the art school of the Berlin Association of Women Artists, for which she was allowed to live alone in the imperial capital at the age of 19, albeit under the supervision of her siblings Konrad and Julie.

Since women were not allowed to study art at state academies in Germany at that time, they had to resort to expensive private lessons. Associations of women artists had therefore been founded since the late 1860s in several cities with lively art scenes; they systematised and professionalised the training of their fledging female colleagues at their own schools. In Berlin, the Berlin Association of Women Artists, founded in 1867, concentrated on training drawing teachers, so that the artists could acquire a basis for gainful employment. In contrast, the Munich Association of Women Artists, which was not founded until 1882, focused on painting.

In the 1880s, Munich was still considered the leading art city in Germany. Berlin was not to take over this position until the 1890s. Both cities,

3 *Woman at a Cradle*, 1897, etching

**4** *Scene from 'Germinal', 1893, etching*

though, certainly had a more lively art scene than Königsberg in East Prussia. Käthe experienced this for the first time in 1886, when she stopped in Berlin with her mother and younger sister Lisbeth on their way to a holiday in Switzerland. Here she met the young writer Gerhart Hauptmann (1862–1946), a neighbour of her sister Julie, and witnessed lively discussions about current trends in literature and the fine arts. During her subsequent study visit to Berlin in the winter semester of 1886/87, she became acquainted with the work of Max Klinger (1857–1920). The symbolist's etching series in particular aroused the public's interest at the time in the way the works confronted social taboos. They stimulated the interest of the budding graphic artist. Her most important teacher at the school for women artists in Berlin was the Swiss graphic artist and painter Karl Stauffer-Bern (1857–1891), a friend of Max Klinger, who trained and encouraged Käthe's talent for drawing in particular.

After her stay in Berlin Käthe had to return to Königsberg, where she received further private lessons from the history painter Emil Neide (1843–1908). From 1888 to 1890 she continued her training in Munich. Käthe later named the portrait and history painter Ludwig Herterich (1856–1932), who was to become a member of the board of the Munich Secession artists' association in 1892, as her teacher during this period. In addition to her lessons at the school for women artists, Käthe joined a group of students who practised different techniques and subjects on their own. In her 'Retrospective of Earlier Times' from 1941, she remembered: 'A theme was set for these evenings. I remember the theme of "battle". I chose the scene from *Germinal*, where two men fight over the young Kathrin in a smoky pub. This composition was accepted.

**5** *Hand Study*, 1891
Pen and brush drawing

For the first time I felt confirmed on my path.'³ Over the years, the drawing *Fight in a Pub* developed into the etching *Scene from Germinal* (4), which was to become part of a graphic sequence on Emile Zola's novel *Germinal*, but was abandoned in 1893 in favour of work on the cycle *A Weavers' Revolt*.

Kollwitz experienced this period in Munich as free and untroubled; she forged what would become lifelong friendships with artists, such as with Beate Jeep (1865–1954), Maria Slavona (1865–1931), Paul Hey (1867–1952) and Otto Greiner (1869–1916). 'The liberated attitude of the "*Malweiber*" [painter women] delighted me. […] The day was occupied with work, in the evening you enjoyed yourself, went to beer cellars and felt free.'⁴ The women artists in particular were emancipated and contemptuous of all social conventions. Her colleagues in Munich were all the more surprised when Käthe suddenly returned to her studies as the fiancée of the aspiring doctor Karl Kollwitz. Her friend Beate Bonus-Jeep described this disconcerting occurrence later on: 'something equally astonishing was to be seen on her: she wore a thick, smooth gold ring on her hand, the talented Schmidt was engaged, simply engaged in a bourgeois way. […] Our stance at that time was that celibacy was considered indispensable for a serious painter.'⁵ Käthe had decided to

**6** *Portrait of Konrad Hofferichter*
1888–90, oil on canvas

marry, even against her parents' expectations. Despite her father's doubts, she held fast to her goal of working as a visual artist, reconciling her profession with marriage and family.

Käthe's fiancé, Karl Kollwitz (1863–1940), was a school friend of her brother Konrad and came from a difficult family background. Born in Rudau in East Prussia, he and his sister Lisbeth (1866–1900) lost their parents at an early age and lived for a time in an orphanage. Despite the poor conditions, the siblings were able to complete high school. Lisbeth became a teacher, while Karl first studied medicine in Königsberg and in 1889 opened a medical practice in the Mitte district in Berlin. After their marriage in 1891, Käthe followed him to Berlin.

But first she finished her training in Munich in September 1890 and returned to Königsberg, where she rented a small studio. The first commissions started to arrive: 'I will become a Croesus here. One portrait commission is already fixed and others will hopefully follow [...].'[6] Nothing more is known about this commission, but a portrait of her young nephew Konrad Hofferichter (6), one of the few surviving paintings by the artist, dates from this period.

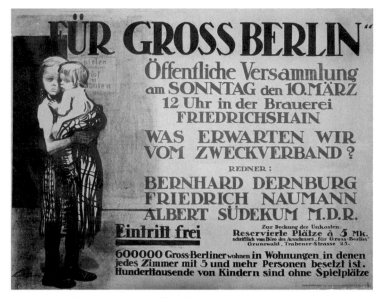

7  *'For Gross Berlin'*, poster 1912, crayon and brush lithograph

Six months later, however, her marriage and move to Berlin were definite and painting was abandoned in favour of printmaking: 'During this first period here [in Königsberg], I conceived a big plan to paint a picture, the quarrel scene from *Germinal*, which I had done as a charcoal sketch in Munich. And then I went at it bravely. But I got stuck. I can't paint the picture until spring, I can't continue it in Berlin, so I'll do all the preliminary studies I need for it and etch the whole thing once I've had more practice in etching.'[7]

## BERLIN – PARIS – FLORENCE

In the summer of 1891, the newly married couple Karl and Käthe Kollwitz moved into a flat in Weissenburger Strasse in the Berlin district of Prenzlauer Berg – at the time a humble residential area that was also home to Berlin's largest homeless shelter, the infamous 'Palme', which could provide night quarters for up to 5,000 people.

Karl had initially opened his first practice in the Rosenthaler Vorstadt neighbourhood in the central district of Mitte;[8] the move to Prenzlauer Berg seems to have been mainly motivated by the fact that the family flat and the doctor's practice could be combined here. After living at first in very cramped conditions, a second flat was rented for the family and Käthe Kollwitz set up her studio space in the doctor's practice, as an art critic described shortly after 1900: 'On the stairs of the house I entered, I found a crowd of poor women bringing their sick children to the doctor, the artist's husband, for treatment. I was shown into a large room that served as a studio. In one corner was a box full of loose sheets and drawings, next to it a press.'[9]

If one looks a little more into the labour of Käthe Kollwitz's husband, one can discover implications for the artist's work. In a much-quoted sentence from her diary she wrote that 'I want to have an impact on these times, when people are so helpless and in need of assistance.'[10] From the beginning of his medical career, Karl was involved in social democratic workers' organisations. He gave courses in first aid and lectured on the widespread disease of tuberculosis, as well as on the connections between illness and living and working conditions. In 1892 Karl became the medical officer of the tailors' trade group. In this context, he worked from 1895 on with the 'Workers' Sanitary Commission' to document the poor working and living

conditions of workers in the clothing industry. He also consulted the child protection commission medically in cases of the neglect and maltreatment of children from 1893 on.[11]

Käthe Kollwitz's early poster work must therefore be seen in direct connection with her husband's work, such as the poster for the Cottage Industries Exhibition of 1906 or the poster against the Berlin housing shortage of 1912 (7). However, an empathy for her immediate surroundings and the integration of these impressions in her work only developed after she had come into closer contact with working-class people through her husband's work. At first, the young artist had been interested in fresh, new motifs beyond the idealised academy depictions primarily from an artistic point of view. This had been a trend in modern painting since the painters of the Barbizon School had begun to depict field workers in the mid-nineteenth century. Kollwitz explained her fascination with the image of ordinary people in her memoirs: 'The real motive, however, why I […] chose to depict almost exclusively the working-class life, was because the motifs chosen from this sphere gave me, simply and unconditionally, what I found beautiful. The Königsberg porter was beautiful to me, […] the generosity of the ordinary people's movements was beautiful. People from the bourgeoisie had no charm for me. The entire bourgeois life seemed pedantic to me. […] I only want to emphasise once again that initially I was drawn to the depiction of proletarian life to a very small extent by compassion and empathy.'[12]

Consequently, the first graphic works Käthe worked on in Berlin were often inspired by literature. In addition to the work on *Germinal*, which she had already begun in Munich, there are, for example, attempts at the Gretchen theme in the context of Goethe's *Faust*. All these works, however, were displaced by Gerhart Hauptmann's drama *The Weavers*, of which Kollwitz had seen an early performance in 1893 'burning with anticipation and interest'. 'The impression was tremendous. […] This performance was a milestone in my work.'[13]

In an agonisingly slow process that was to become characteristic of her production, by 1898 she had created a cycle of six small-format prints – three lithographs and three etchings – inspired by Hauptmann's drama (8–10). In *A Weavers' Revolt*, Kollwitz depicts the living conditions of the cottage-industry weavers, whose children die young while their mothers likewise have a short life expectancy. The pent-up anger at the exploitative

**8** *Need*, sheet 1 from the cycle *A Weavers'
Revolt*, 1893–97, lithograph

**9** *March of the Weavers*, sheet 4 from the
cycle *A Weavers' Revolt*, 1893–98, etching

**10** *End*, sheet 6 from the cycle *A Weavers'
Revolt*, 1893–97, etching

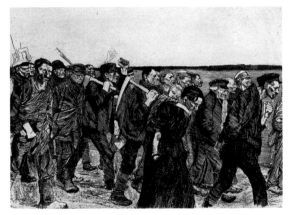

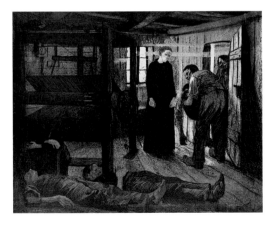

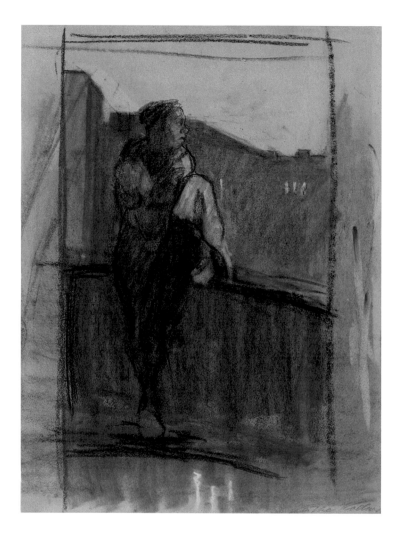

11 *Woman on the Balcony. Self-Portrait*
1892–94, charcoal and crayon drawing

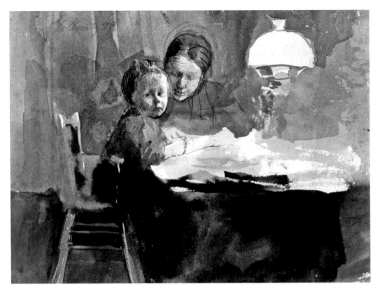

**12** *Hans Kollwitz with Nurse*, 1894, pen and brush drawing

conditions explodes in a march of the weavers to the factory owner's mansion. The desperate attempt to storm the house fails. The uprising ends with the men being killed and taken to the weavers' room. Kollwitz creates gloomy scenes rich in detail, which she structures with painterly chiaroscuro effects. Her prints are not an illustration of the play, nor are they clearly situated in the Silesian weavers' revolt of 1844. Kollwitz's cycle, despite its narrative depiction, could just as well portray the conditions of Berlin's home workers in the textile industry.

Kollwitz presented her series of prints for the first time at the Great Berlin Art Exhibition in 1898. If Hauptmann's naturalistic drama had already attracted a great deal of attention, Käthe Kollwitz's graphic interpretation marked her breakthrough as a visual artist: 'All of a sudden, from then on I was counted in the front rank of artists. [...] This great success arrived surprisingly, but was no longer threatening.'[14] She wrote to her long-time friend Beate Bonus-Jeep with relief: 'I sold the weavers at the big exhibition for five hundred marks. Isn't that splendid? At last, at last, the problem child was ready to be exhibited. I put it in a beautiful frame and sent it to the exhibition. It was hung beautifully and sold on the third day.'[15]

From this point on, the most important buyer of her art was Max Lehrs (1855–1938), the director of the Dresden and subsequently the Berlin Kupferstichkabinett (Cabinet of Prints and Drawings). He made it his mission to collect the work of the young artist as completely as possible and in all its facets. Lehrs also became the most committed defender of Käthe Kollwitz, who was exposed as a woman to the prejudices of the male-dominated art world, especially in her early years.

Käthe Kollwitz had shown at exhibitions, mostly women's art exhibitions, only a few times before the presentation of *A Weavers' Revolt* in 1898. However, her first participation as early as 1893 in the Free Berlin Art Exhibition had not gone unnoticed. This show had been organised by artists who had been rejected by the jury at the official Great Berlin Art Exhibition because of their modern view of art. They included Max Liebermann (1847–1935), Walter Leistikow (1865–1908) and Ludwig von Hoffmann (1861–1945), established artists who gave the young Käthe Kollwitz a chance to present herself.

At her first public appearances, she presented mostly drawings, some of them in colour: studies from her surroundings, which often depicted the artist herself, leaning pensively on the balcony (11) or sitting attentively at the table. During this period, she often depicted seated, exhausted women, explored the play of light and shadow on women's faces or took her own son as a model (12).

Overall, however, her works had little public presence in the 1890s. One reason for her restrained exhibition activity may have been the birth of her sons Hans in 1892 and Peter in 1896. However, the artist was only slightly burdened with household duties; the children were cared for by a nanny. The elder son Hans remembered his mother: 'Mother never developed the skills of a housewife, nor was she interested in them. Apart from tea and coffee and fried eggs in her Munich student days and in the studio, she probably never cooked. In order to be able to do her artwork, she handed over everything concerning the household to our Fräulein Lina.'[16] Her low public profile, therefore, can be explained instead by her slow working method, which in turn is rooted in her overly critical view of her work.

After the success of *A Weavers' Revolt*, however, Käthe Kollwitz was regularly present at exhibitions. As early as 1899, she was invited to the first show of the newly founded Berlin Secession, which accepted her as a member in 1901. From 1912 on, she was also a member of the board of this modern art

13 *Woman with Orange,* 1901
Combination print

**14** *Female Nude, from behind, on Green Cloth*, 1903
Crayon and brush lithograph

association. In 1901 she became a member of the Berlin Association of Women Artists, which had once provided her with an initial training ground and where she taught graphic art and drawing after 1897. She immediately became a member of the Deutscher Künstlerbund, which was founded in 1903, and was also active in several women's art associations. As early as 1901, works by Käthe Kollwitz were shown abroad for the first time, in Paris and London. At the beginning of 1901, Kollwitz paid a short visit to the French capital. She met her old fellow student Maria Slavona there again, whose husband Otto Ackermann (1871–1963) showed her around the city's galleries. She visited the then famous printmaker Théophile Steinlen (1859–1923) in his studio and was enthusiastic about the colour printmaking that dominated Paris at that time.[17]

While Kollwitz had previously used pastel and watercolour for coloured works, she now became acquainted with the possibility of working in colour in printmaking as well. For a short time she experimented with this technique. By the autumn of 1901, she exhibited *Woman with Orange* at the Secession, a combination of lithography and etching with sparingly used coloured accents (13). Her increasing mastery of this technically demanding method of working with different colour stones and printmaking techniques is best documented in *Female Nude, from behind, on Green Cloth* from 1903 (14).

In 1904 Kollwitz returned once again to this city that 'enchanted' her and stayed for two months. At the Académie Julian art school she tried to acquire the basics of sculpture. Her interest in sculpture had been awakened around 1903 and also began to be reflected in her graphic works. Her first sculptural work was a portrait relief for a memorial stone to her grandfather Julius Rupp, which was unveiled in Königsberg in August 1909.

In Paris, Käthe found herself in a circle of fellow German artists that included the painters Maria Slavona, Ida Gerhardi (1862–1927) and Sophie Wolff (1871–1944). They were joined by the art dealer Wilhelm Uhde (1874–1947), who had just moved to Paris. In addition to her lessons at the Académie Julian, she spent her afternoons in the museums and her evenings in the city's taverns, 'which at that time were still home to a truly dangerous underworld of criminals, with whom we […] nevertheless got on very well and from whom Käthe Kollwitz drew much artistic inspiration'.[18] If her first stay in Paris had inspired her to experiment with colour, her visits to bars and dance halls now served to study types that would be found in later graphic works. She was able to visit the sculptor

she strongly admired, Auguste Rodin (1840–1917), whose sculptures were to accompany her for a long time and inspire her early, often unfinished sculptural works.

While Paris had stimulated her artistically during her two visits, her stay in Florence was uninspiring. In 1906, Käthe Kollwitz was awarded the Villa Romana Prize, which gave scholarship holders the opportunity to spend time working in Italy. The following year she went to Florence for a few months. Although her friend Beate Bonus-Jeep also lived near the city and they visited each other, the stay was not artistically fruitful for Kollwitz. She recalled that 'although I had a nice studio in the Villa Romana, I didn't work at all.'[19] Even in her recollections of this period, written in 1941, the relief that her time in Italy was over is palpable. The stay there, however, proved to be a turning point in the evolution of her work, concluding her early phase.

## SIEGMUNDS HOF

The large-format series of etchings on the *Peasants' War*, completed in 1907, represents the link between the early work and the mature period in Käthe Kollwitz's oeuvre. Compared to the prints of *A Weavers' Revolt*, the significantly larger sheets testify to the artist's healthy self-confidence, both in terms of her technical mastery of the large etching copperplate and her confidence in creating the composition. Once again, Kollwitz drew inspiration from literature, this time from Wilhelm Zimmermann's (1807–1878) monograph, for a print series whose theme had fascinated her since 1899. The 1901 print *Charge* prompted the 'Association for Historical Art' to commission a graphic cycle on the Peasants' War from the artist in 1904.

The series comprises seven etchings. After the detailed depictions of *A Weavers' Revolt*, Kollwitz now depicted her motifs in a more concentrated yet expansive manner. The first print, *The Ploughmen*, with its low horizon and the ploughmen arranged parallel to the ground, shows the change in Kollwitz's approach. The depiction of *Sharpening the Scythe* concentrates on the bust portrait of the woman and her grimly determined gesture of whetting the scythe. The image of the *Charge* is much more dynamic than the *March of the Weavers*. Kollwitz employed an unusual pictorial device, very much in vogue in French art at the time, in the foreground figure of

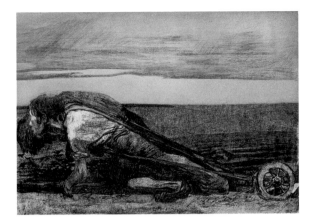

15  *The Ploughmen*, sheet 1 from
the cycle *Peasants' War*, 1907, etching

16  *Sharpening the Scythe*, sheet 3 from
the cycle *Peasants' War*, 1905, etching

17  *Charge*, sheet 5 from the cycle
*Peasants' War*, 1902/03, etching

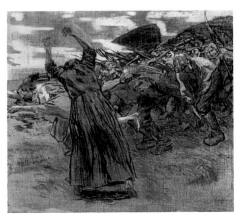

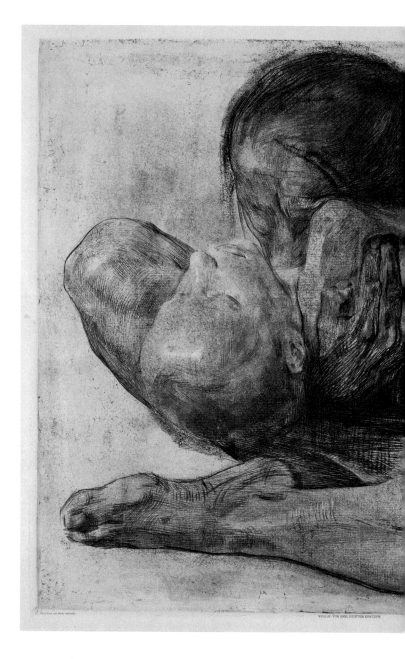

**18** *Woman with Dead Child*, 1903, etching

the woman seen from behind. The print *Raped*, which depicts a ravished woman lying on the ground, certainly has a disconcerting impact. Here, too, the observer's gaze is led very close to the event. By contrast, Käthe Kollwitz developed a touching scene full of tender mourning in the print *Battlefield*, in which a woman searches for her child among the slain insurgents.

Kollwitz had worked on the theme of a woman with a dead child for several years, concentrating on different aspects and creating an image around 1903 that represented the embodiment of a mother's pain (18). Contemporaries' reactions to these pictorial inventions by Käthe Kollwitz were ambivalent for a long time. Her friend from art school and critic Anna Plehn (1859–1918) described her reaction to the work in 1904: 'I don't think many will see this print without first feeling a violent shock run through their limbs.'[20]

In images such as these, Kollwitz found representational possibilities that went beyond literary or real events. Surroundings, utensils and chiaroscuro effects were abandoned in favour of pictorial creations that focused entirely on human conditions and sensations. The formal language became more physical and thus more sculptural. At the same time, it is perceptible how Käthe Kollwitz was now also emotionally moved by the impressions of her environment: 'When I became acquainted, especially through my husband, with the severity and tragedy of the depths of proletarian life, when I met women who came to my husband, and also to me, looking for help, the fate of the proletariat and all its consequences gripped me with all its force.'[21]

In addition to the motif of the death of children and the pain of mothers, it was above all themes such as the poverty of families, the unwanted pregnancies of women, unemployment (19) and the poor housing and working conditions, which in turn led to illness and mortality, that Kollwitz brought to public attention with her drawings and prints. From 1908 onwards, she was able to publish many drawings dealing with these issues in the renowned, socially-critical magazine *Simplicissimus*. She also made her graphics available to illustrate socio-political publications.

Kollwitz thus achieved a high level of attention for her concerns, especially as she also positioned herself politically in several initiatives. Kollwitz as a person became widely known alongside her artistic work. And the public began to see the work and the person as one. Her son Hans remembered his mother quite differently: 'How much could mother laugh and how she longed to laugh! People who only experienced her listening with her good,

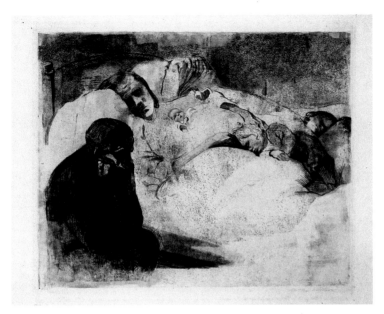

19 *Unemployment*, 1909, etching

sad eyes, or who only knew her from her works, only knew a part of her, not the part that took pleasure in affirmation, in young people, in wit, in exuberance, in humour.'[22]

Other important motifs in her oeuvre were portrayals of women that captured faces scarred by life's circumstances. But the artist also subjected her own countenance to intensive questioning, so that there are unsparing self-portraits from all phases of Käthe Kollwitz's life (20).

Surprisingly for many, however, nudes appear in her drawings and prints as well, showing both men and women posing as models. This may be an indication of her efforts to create three-dimensional works. After the portrait relief for her grandfather, she was preoccupied with several sculptural ideas that initially did not get beyond the draft stage and are only documented in photographs. These included depictions of mother and child and of the motif of the pair of lovers. In 1912 Kollwitz took a decisive step further in sculpture, renting her own studio in Berlin for the first time. She found a room in the Siegmunds Hof studio building in the Hansaviertel district.

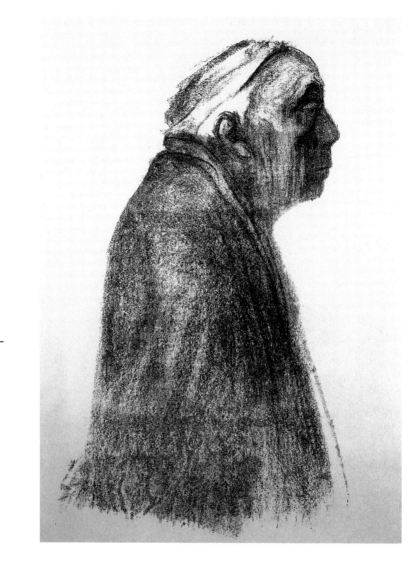

20  *Self-Portrait in Profile towards left*, 1938, crayon lithograph

Käthe Kollwitz summed up these years prior to the First World War in a thoroughly positive way: 'The last years before 1914 brought many good things for all four of us. Karl and I lived in our work. Hans had begun to study at the university [...] Peter had left school at the end of the 11th class at his urgent request. He wanted to become a painter.'[23] The outbreak of the First World War changed everything, however. Peter, still a minor, obtained permission from his parents to volunteer for the war effort and fell after only 14 days on the Western Front. In her pain and grief, the artist tried to process the terrible experience artistically. She received encouragement from her fellow artists: 'Liebermann wrote to me: Work. I worked.'[24]

In an initial impulse to come to terms with the grief of her son's death, Kollwitz turned to sculpture. She planned a large memorial for the fallen volunteers of the First World War. She conceived a three-part group of figures in her studio in Siegmunds Hof, consisting of a soldier lying down flanked by kneeling parental figures. Only a few photographs exist of the arduous working process, which was interrupted by depressive phases and illnesses. Kollwitz hardly did any graphic work during the war, but she ventured into the public arena for the first time with a sculptural work. After some hesitation, she presented the group *A Pair of Lovers* (21), on which she had long worked in various versions, at the spring exhibition of the Free Secession in 1916. And she was proved right in her reticence: 'The exhibition of my first sculpture is a failure. The critics are silent or declare the work inferior to my graphics.'[25] Nevertheless, she doggedly pursued her ambitions to create sculpture and also presented some sculptural works at her major exhibition on the occasion of her 50th birthday in 1917.

At this first solo exhibition of the artist's work at Paul Cassirer's renowned gallery, the focus was not on Kollwitz's prints but on her drawings. With 160 sketches, studies, coloured sheets and large-format drawings in various techniques, the exhibition offered a hitherto unseen overview of the artist's diverse production. The 50 prints also on display were almost lost in the overwhelming abundance of drawings. Kollwitz the draughtswoman was discovered in this exhibition. She proudly wrote to her son Hans: 'The success is great. They tell me at Cassirer that they now have a full house again. I have sold almost everything that hangs there [...].'[26]

Here, too, little attention was paid to the presentation of sculptures, which were not listed individually in the catalogue. Nevertheless, Kollwitz continued to work on her monument to the volunteers, although the course of the

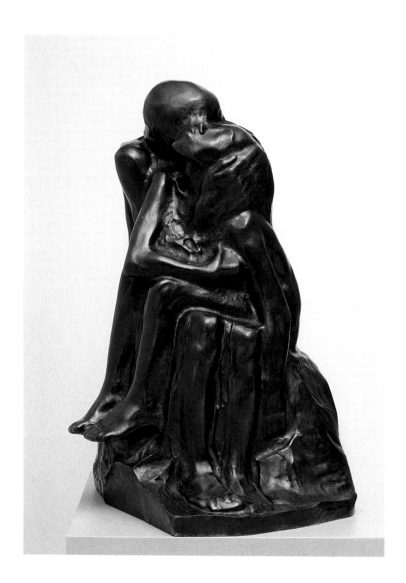

21  *Lovers*, 1913/15, bronze

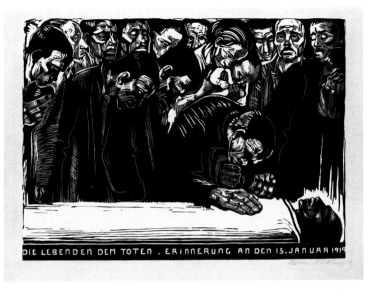

DiE LEBENDEN DEM TOTEN . ERiNNERUNG AN DEN 15.JANUAR 1919

**22** *In Memoriam Karl Liebknecht*
1920, woodcut

First World War made her despair in view of the large number of young men who had fallen. When in October 1918, in an already hopeless situation, the poet Richard Dehmel (1863–1920) again called for voluntary enlistment for military service, Käthe Kollwitz also turned to the public and published a response in the social-democratic newspaper *Vorwärts*, her resolute 'Enough dying! No one must die anymore!' (see also page 74).[27] A year later, Kollwitz found that she could not finish her memorial for the volunteers who had once gone joyfully to war. She stopped work on the ensemble of figures for the time being and turned to the problems of the revolution, the post-war period and the democratic Weimar Republic, which was only consolidating itself with difficulty.

## YEARS OF SUCCESS

After 1919, art academies were opened to women and Käthe Kollwitz was allowed to vote for the first time. She experienced a great honour when

she was the first woman to be appointed to the Prussian Academy of Arts. As in the Secession association, she attained the position of a pioneer for subsequent women – a role that she was not always comfortable with, but which she took on.

Artistically, the graphic arts slowly came to the fore again, along with the need to process the war period artistically. She began a *War* series which, unlike her male colleagues, did not focus on the experience at the front, but on the situation of the survivors, the parents, wives and children whose sons, husbands and fathers had fallen in the war. Again, she struggled for a long time with meaningful motifs and with the technique. She quickly discarded etching, as lithography seemed too gentle to her. It was only in the woodcut that Käthe Kollwitz would achieve the expressiveness that seemed appropriate for the subject.

After seeing woodcuts by Ernst Barlach (1870–1938) in an exhibition, she turned to this technique, which was new to her. Her first works dealt with the death of the socialist leader Karl Liebknecht, who had been murdered together with Rosa Luxemburg in January 1919. Liebknecht's funeral turned into a large workers' demonstration, to which Kollwitz dedicated the print *The Living to the Dead. Remembrance of 15 January, 1919* (22). Another three years would pass before she completed her *War* series. In seven large-format prints Kollwitz dealt with her trauma of the death of her younger son in a starkly contrasted and concise pictorial language. The prints *The Sacrifice* and *The Volunteers* (23, 24) refer to the situation in which she, as a mother, had supported her son's wish to take part in the war voluntarily and this 'sacrifice' had led to the death of the 'volunteers'. The parents kneeling in desperate grief (25), like the mothers standing in a circle (26), symbolise the fate of all those left behind. Kollwitz would pursue both pictorial inventions in a three-dimensional format.

The artist was not to work frequently with the woodcut, and yet she produced other surprising and impressive prints in this technique, such as self-portraits of 1922 and 1924 or the late work *Maria and Elizabeth* of 1929 (27). Kollwitz also created a striking woodcut for the posters that were increasingly produced during this period to help an initiative against the famine in Russia (29).

As a rule, however, she executed the numerous posters she had created in the 1920s a second time as lithographs. Kollwitz supported numerous initiatives against the hunger that prevailed in Europe after the end of the World War, for the return of prisoners of war and above all against war. In addition

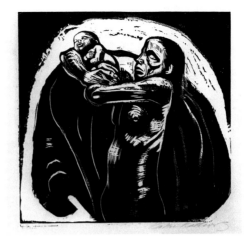

**23** *The Sacrifice*, sheet 1 from the series *War*
1922, woodcut

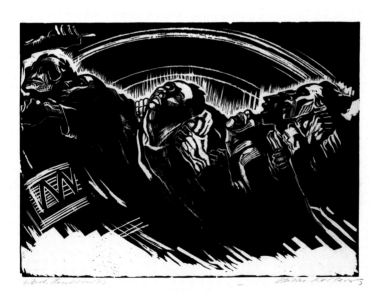

**24** *The Volunteers*, sheet 2 from the series *War*
1921–22, woodcut

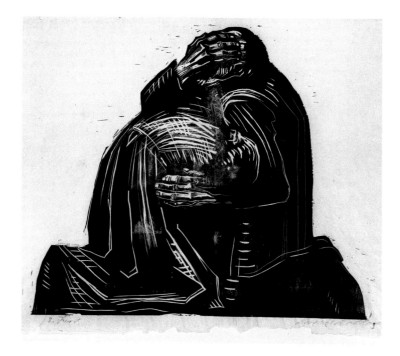

**25** *The Parents*, sheet 3 from the series *War*
1921–22, woodcut

to her famous poster *Never Again War* (2), she created other motifs that were distributed internationally (28).

Throughout her life, Käthe Kollwitz stayed free from party politics. Through her family she was close to social democracy, especially as her husband Karl had become a city councillor for the SPD (Social Democratic Party) in Berlin in 1919. However, she was also open to concerns of the KPD (Communist Party): 'I felt more drawn to the communists than to social democracy and made various lithographs for them, since they, much more lively and active than the social democrats, always called on me to do so.'[28] Her pacifist stance brought her into contact with Albert Einstein (1879–1955), and together they were active in many initiatives. The young painter and communist Otto Nagel (1894–1967) established connections with the Soviet Union, which resulted in exhibition opportunities for Käthe Kollwitz.

In the 1920s, her works were shown at numerous exhibitions, as well as in other European countries and in the United States. As a member of the academy, she was entitled to show her work at the spring and autumn presentations of the Prussian Academy, and did so regularly. She frequently attended the Academy meetings of the Fine Arts Section and, despite the considerable time commitment, was involved in various commissions, such as the important Exhibition Commission, to which she was elected right at the beginning of her membership. She retained this office until 1925, and from 1930 until her enforced resignation from the Academy in 1933, she again helped to organise the exhibitions. For her 60th birthday in 1927, she was given the honour of a collective show in which she was able to present over 90 works, most of them loaned from museums or collectors.

Her fame as an artist, which had marked the 1910s, increased in the 1920s to such an extent that Käthe Kollwitz was perceived by the general public as a moral authority. This was due not only to her commitment to pacifist and social initiatives, but also to her struggle for the memorial to the First World War.

Politically, the Weimar Republic was soon so polarised that a national commemoration of the victims of the war could not be realised. Each federal state, each municipality, created its own memorial sites, which were characterised by very different ideas. Only a few addressed the horrors of war; the pathos of heroic commemoration, often combined with revanchist messages, gained the upper hand.

**26** *The Mothers*, sheet 6 from the series *War*
1921–22, woodcut

During this period, Käthe Kollwitz began to resume her project of a monu-
ment to her son Peter, which had been abandoned in 1919, and concen-
trated on creating a group of figures for the military cemetery in Roggevelde,
Belgium, where her son had been buried. By the time of the Academy's
autumn exhibition in 1931, she had completed a pair of parents kneeling in
plaster that expressed quiet mourning in a manner that was as simple as it
was eloquent, thus reflecting the mood – beyond political bickering – of
those affected by loss. Before the figures, now carved in stone, were trans-
ported to their destination, the National Gallery presented the completed
work in June 1932 (30). Käthe Kollwitz noted in her diary: 'Today, 15 June,
the works have been in the National Gallery for a fortnight. Many people
have seen them and they have made a strong impression.' And a little later:
'They have an impact.'[29]

And so an important artistic and personal concern of Käthe Kollwitz came
to a conclusion, shortly before the Nazis seized power. At the same time,
an important phase in the artist's life came to an end. She seemed to have
consolidated her fame by being honoured with the medal 'Pour le mérite'
and by taking on a master class at the Academy.

## THE LATER WORKS

In 1932, Käthe and Karl Kollwitz, together with several other prominent
people, made an 'urgent appeal' for the left-wing parties to unite against
the NSDAP (Nazi party). When the National Socialists assumed power in
the Reich in 1933, Käthe Kollwitz and her family were immediately sub-
jected to various restrictions. Because of their political commitment and
Karl Kollwitz's affiliation to the SPD, measures were promptly taken
against them. Käthe Kollwitz had to resign from the Academy of Arts, give
up her master class and vacate her studio at the Academy. Karl Kollwitz's
health insurance licence was withdrawn and his son Hans, who worked in
the public health service, was suspended. After several weeks, however,
the regime rescinded the measures against father and son.

Käthe's brother-in-law Georg Stern's retirement benefits were reduced be-
cause of his Jewish descent, so that his wife Lisbeth was severely restricted
financially after her husband's early death in 1934. Their eldest daughter
Regula was not allowed to continue practising as a doctor; their daughter

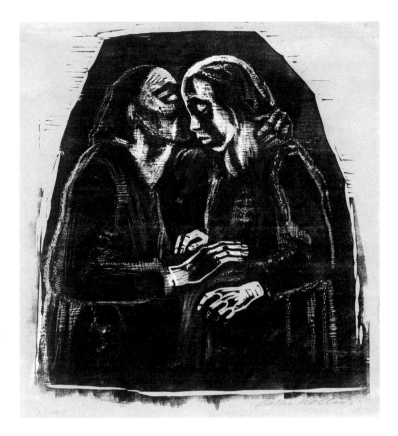

**27** *Maria and Elizabeth*
1929, woodcut

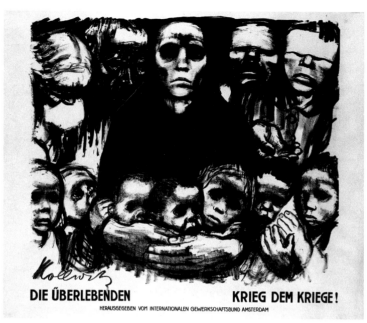

DIE ÜBERLEBENDEN    KRIEG DEM KRIEGE!

HERAUSGEGEBEN VOM INTERNATIONALEN GEWERKSCHAFTSBUND AMSTERDAM

**28** *The Survivors*, 1923
Crayon and brush lithograph

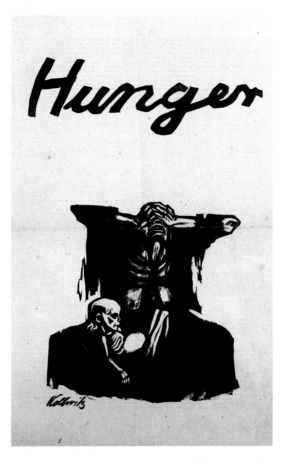

**29** *Hunger*, 1922, woodcut

Johanna, married to the famous director and actor Fritz Kortner (1892–1970), emigrated to the USA, as did their youngest daughter Maria. Both saw no more professional opportunities for themselves as actresses in Germany. Karl and Käthe spent March 1933 in Marienbad, which had belonged to Czechoslovakia since 1918: 'We forget that we are in a refuge,' Karl wrote to his son.[30] But they returned to Berlin and Käthe soon began to work again. Two major projects occupied the artist in the following years. Graphically, she wanted to deal with the subject of death, and sculpturally, she worked intensively on her second large sculpture with a mother and child motif.

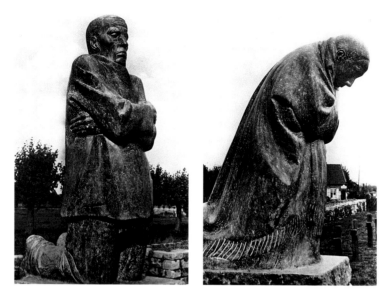

**30** *Grieving Parents* at the military cemetery Roggevelde, Belgium (historical photograph)

As early as 1924, Käthe Kollwitz had published a portfolio of facsimile drawings under the title *Departure and Death* and had also considered a series of prints to accompany it, which she now realised in the early 1930s. The series represents a résumé of the artist's decades-long preoccupation with the many faces of death, which she situated between struggle, submission and trusting expectation. In several prints she made direct reference to the drawings in the portfolio *Departure and Death*. The lithographs *Young Girl in the Lap of Death* (31) and *Death seizes a Woman* are transfers of the charcoal and crayon drawings into prints. For the horrific death of a child she reworked the dramatic depiction *Death seizes the Children*.

The great subject that had always absorbed her, the depiction of mother and child, also began to be treated sculpturally from the 1910s on. Several years were to pass between the first attempts with a woman fighting for her child to a lovingly embracing mother. After completing the memorial to those fallen in the war in 1932, Kollwitz turned her attention entirely to the group *Mother with Two Children*, which she had already drafted. By this point in time, in 1933, she was supposed to have left her large academy studio. The academy directors, however, allowed her to remain in the stu-

dio until she could have the large group in the fragile material of clay rendered in the more stable plaster. At the end of 1934, she was able to obtain a new workroom in the Klosterstrasse studio building and completed the sculpture there.

She was lucky to be able to rent the space, because the allocation of studio space was subject to Nazi state supervision. Moreover, the couple's income from both their medical practice and art sales had plummeted. But they were able to come to an arrangement, as she wrote to her exiled friend Helene Bloch in Prague in 1939: 'We can still keep a studio in Klosterstrasse, and to my delight there are still people who quietly hold my work in high regard. Yes, there are even those, even within Germany, who still buy it.'[31] But she also received very practical support, for example from her fellow artist Leo von König (1871–1944), who donated funds in 1936 so that she could have the large and powerfully modelled group *Mother with Two Children* (33) carved in stone.

However, as soon as her work entered the public sphere and was displayed at exhibitions, Kollwitz experienced bans and rejections. For example, in 1936 on the occasion of an anniversary show of the Academy of Arts, to which she had been invited to submit works, and again in 1937 at a solo exhibition on her 70th birthday. The Cassirer Gallery, which had shown Kollwitz extensively in 1917, no longer existed. The Academy, which had honoured her in 1927, had expelled her as a member. The planned exhibition at the Nierendorf Gallery was cancelled because of feared difficulties. The Buchholz Gallery then stepped in, but had to submit to the closure of the Kollwitz exhibition by the authorities.

And so the person Käthe Kollwitz soon disappeared from the public eye of the Nazi state along with her work. She continued to work, however, despite being plagued by old age, worries about her husband, who was to die in 1940 after a long illness, and without any reaction from the art world. She almost completely abandoned her graphic work and instead devoted herself to sculpture, which she executed in small formats. She took up old themes again, especially mothers protecting their children. The *Tower of Mothers* (1), completed in 1938, refers to the mothers from the series *War* of 1922 (26). From 1937 on she worked on the group of figures *Mother with Dead Son* (35), which she also called *Pietà*, in memory of her dead son Peter and in increasing concern about another war. She commented very clearly in her diary on the outbreak of war in 1939: 'Of course, this is no longer

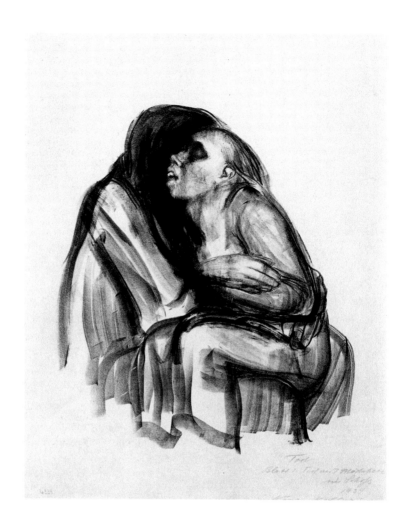

**31** *Young Girl in the Lap of Death*, sheet 2 from the series *Death*, 1934, crayon lithograph

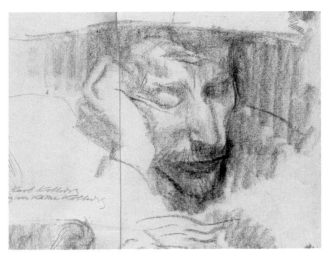

**32** Detail from the portrait study: *Dr. Karl Kollwitz*, 1940, pencil drawing

about Poland and the Corridor or Danzig. The confrontation between the authoritarian states and the democratic states has begun.'[32]

The war launched by the Nazi regime led Käthe Kollwitz back to graphic art, the medium in which she could and wanted to work. In 1941, she created the lithograph *'Seed for Sowing Should Not be Milled'*, with a mother energetically holding back her children with arms outstretched (34). She described this recurring motif in her work, placed under the quotation from Goethe, as her last will: 'This demand, like *Never Again War*, is not a wistful wish, but a commandment. A demand.'[33]

In 1943 Käthe Kollwitz had to leave her home. The war had returned to Germany, the bombing raids increased and the artist was evacuated from the city. At first she found refuge in the Harz Mountains with the sculptor Margret Böning (1911–1995), who in August 1943 took in Käthe, her sister Lise and niece Katharina. In 1944, Käthe Kollwitz moved into accommodation in Moritzburg Castle near Dresden, while her sister and niece were accommodated near Altenburg. Despite the approaching hostilities, Kollwitz was visited frequently by her sister Lise as well as by her son Hans, and her granddaughters Jördis and Jutta looked after her until shortly before her death. Käthe Kollwitz died in April 1945 at the age of 77; her urn was transferred to the family grave in Berlin in the summer of 1945.

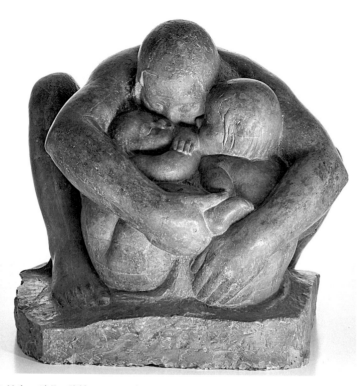

**33** *Mother with Two Children*, 1932–36, plaster

Käthe Kollwitz's art was appreciated early on by experts and entered fa-
mous museum collections. Nevertheless, the public, including some art
critics, had problems attributing this powerful and expressive art to a
woman – at a time when women artists were mainly permitted beautiful,
cheerful and ultimately marginal subjects. On account of their expressive-
ness Kollwitz's works were dubbed 'masculine', while at the same time dis-
paraged as women's art. As late as 1922, Max Lehrs, the great admirer of her
works, felt compelled to clearly state the significance of the artist: '[…] I
always have to smile when I hear well-tempered words of appreciation in

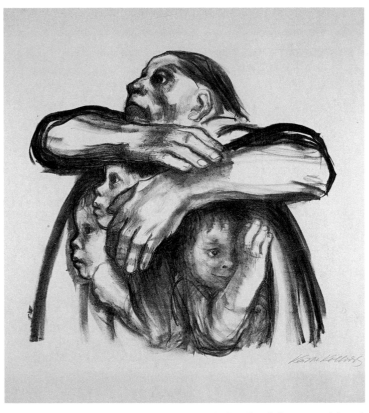

**34** *'Seed for Sowing Should Not be Milled'*, 1941, crayon lithograph

front of her sheets: That is all possible for a *woman*! – My God, how many *men* do we have who could manage a composition like the *Charge* from the Peasants' War series with this elemental force, this unheard-of power and this skill in drawing?'[34]

Unusually for her time, Käthe Kollwitz was one of the women artists who was visible from her early days. Her works were seen in exhibitions and publications, her evolution was followed by art critics and museums and well-known collectors acquired her works. Käthe Kollwitz was celebrated worldwide even during her lifetime and she remains so today.

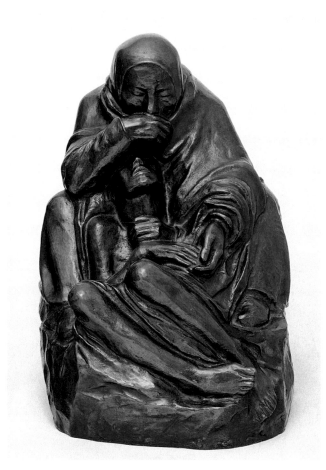

**35** *Mother with Dead Child (Pietà)*, 1937/38, bronze

JOSEPHINE GABLER *is the Director of the Käthe Kollwitz Museum in Berlin. She completed her studies in art history at the FU Berlin with a dissertation on the sculpture of the Nazi era. She has been responsible for the realisation of numerous art exhibitions from the late 19th to the 21st century.*

1 Cf. E.A., 'Rundschau', in *Sozialistische Monatshefte*, 1898, issue 5, pp. 244–246.

2 Käthe Kollwitz, 'Erinnerungen' (1923), in *Käthe Kollwitz. Die Tagebücher*, ed. Jutta Bohnke-Kollwitz, (Berlin 1989), pp. 718, 726.

3 Käthe Kollwitz, 'Rückblick auf frühere Zeit' (1941), in ibid., p. 738.

4 Ibid.

5 Beate Bonus-Jeep, *Sechzig Jahre Freundschaft mit Käthe Kollwitz*, (Bremen 1963), p. 10.

6 Käthe Kollwitz to Paul Hey, 23 September 1890, in *Käthe Kollwitz. Briefe der Freundschaft*, (Munich 1966), p. 18.

7 Ibid., p. 20.

8 See the advertisement for the opening of the practice in the *Berliner Volkstribüne* newspaper from 26 October 1889. The practice was situated in the Fehrbelliner Strasse 42 in 'Berlin N.' (Berlin north). The directory for Berlin records this address until 1891, which however was due to when it was printed. In 1892 Karl Kollwitz operated with his practice in Weissenburger Strasse.

9 Charles Loeser, 'Käthe Kollwitz', in *Sozialistische Monatshefte*, 1902, issue 2, pp. 107–111, here p. 108. Only shortly before the family's private rooms and the doctor's practice were separated, so that now Käthe could have a studio set up on the same storey as the practice. The Berlin directory listed this separation form 1900 on, with the practice remaining on the first storey and the flat on the third. After 1903 the practice was located on the second storey.

10 Diary entry from 4 December 1922, in *Die Tagebücher*, p. 542.

11 Cf. the corresponding reports in the *Vorwärts* newspaper from 16 February and 2 November 1890, from 10 February 1892, 18 July 1895 and 6 May 1913.

12 Käthe Kollwitz, 'Rückblick auf frühere Zeit' (1941), in *Die Tagebücher*, p. 741.

13 Ibid., p. 740.

14 Ibid., p. 741.

15 Quoted in Bonus-Jeep, *Sechzig Jahre Freundschaft*, p. 43.

16 Hans Kollwitz, 'Erinnerungen an meine Mutter', here quoted in *Das Ostpreußenblatt*, 8 July 1967, p. 8.

17 On this cf. Andrea von dem Knesebeck, '"Daß überhaupt der Aufenthalt in Paris – so kurz er war – Anregung in Fülle brachte, brauche ich Ihnen nicht zu sagen." Die erste Parisreise von Käthe Kollwitz 1901', in *'Paris bezauberte mich...'. Käthe Kollwitz und die französische Moderne*, exh. cat. Käthe Kollwitz Museum Köln, ed. Hannelore Fischer and Alexandra von dem Knesebeck, (Cologne/Munich 2011), pp. 83–105.

18 Wilhelm Uhde, *Von Bismarck zu Picasso. Erinnerungen und Bekenntnisse*, (Zurich 1938), p. 119, here quoted in *Die Tagebücher*, p. 876.

19 'Rückblick auf frühere Zeit', in *Die Tagebücher*, p. 743.

20 Anna Plehn, 'Die neuen Radierungen von Käthe Kollwitz', in *Die Frau. Monatsschrift für das gesamte Frauenleben unserer Zeit*, 1903/04, pp. 234–238, here p. 235.

21 'Rückblick auf frühere Zeit', in *Die Tagebücher*, p. 741.

22 Hans Kollwitz, *Erinnerungen an meine Mutter*, p. 10.

23 Käthe Kollwitz, 'Die Jahre 1914–1933 zum Umbruch', in *Die Tagebücher*, p. 745.

24 Ibid., p. 746.

25 Diary entry from 8 February 1916, in *Die Tagebücher*, pp. 221ff.

26 Letter from 22 April 1917, in *Käthe Kollwitz. Briefe an den Sohn*, ed. by Jutta Bohnke-Kollwitz, (Berlin 1992), p. 149.

27 Richard Dehmel's appeal appeared in the *Vorwärts* newspaper on 22 October 1918 on p. 7, Kollwitz' response on 28 October 1918 on p. 3.

28 'Die Jahre 1914–1933', in *Die Tagebücher*, p. 746.

29 Diary entries from 15 and 19 June 1931, in *Die Tagebücher*, pp. 661ff.

30 Letter from 25 March 1933, Akademie der Künste Berlin, Käthe-Kollwitz-Archiv no. 129.

31 Letter to Helene Bloch from 16 July 1939, Akademie der Künste Berlin, Käthe-Kollwitz-Archiv no. 168.

32 Diary entry from September 1939, in *Die Tagebücher*, p. 696.

33 Diary entry from December 1941, in *Die Tagebücher*, pp. 704ff.

34 Max Lehrs, 'Käthe Kollwitz', in *Berliner Tageblatt*, 5 December 1922, evening issue.

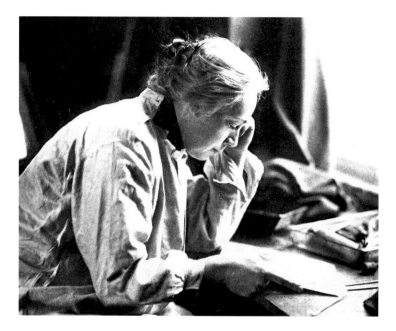

**36** Käthe Kollwitz with copperplate, ca. 1910

# BIOGRAPHY

Käthe Kollwitz
1867–1945

Astrid Böttcher

**1867** Käthe Kollwitz is born on July 8 in Königsberg (present-day Kaliningrad, Russia) as the fifth child of Katharina and Carl Schmidt. She grows up in a middle-class environment with her older siblings Konrad and Julie and her younger sister Lisbeth, known as Lise. The father works as a building contractor; the mother quietly bears her grief over three children who previously died at an early age. The sisters Käthe and Lise are allowed many freedoms and are permitted to move around the city unhindered – only strolling on Königsberg's boulevard is forbidden.

**1881–1886** The Schmidt siblings are nurtured in the Free Christian protestant home; artistic and intellectual interests are stimulated. Carl Schmidt discovers the drawing talent of the two younger daughters early on and encourages them. The ambitious young Käthe eventually receives drawing lessons from Rudolf Mauer (1845–1905) and painting lessons from Gustav Naujok (1861–?).

**1886–1887** While passing through Berlin, Käthe experiences the youthful, lively artistic life of the capital. Through her sister Julie, she meets the poet Gerhart Hauptmann (1862–1946), then still unknown, and his fellow writer Arno Holz (1863–1929).

Käthe continues her artistic training in Berlin at the art school of the Association of Berlin Women Artists, under the supervision of her brother Konrad and her older sister Julie, who both live in Berlin. Her teacher, the graphic artist and painter Karl Stauffer-Bern (1857–1891), encourages Käthe to turn to graphic art. She begins to study the graphic work of Max Klinger (1857–1920). Back in Königsberg, she receives instruction from the history painter Emil Neide (1843–1908).

**1888–1890** Käthe becomes engaged to Karl Kollwitz (1863–1940), a school friend of her brother Konrad. Karl is about to graduate from medical school and afterwards successfully completes his practical training in Berlin. Meanwhile, Käthe attends the painting class of Ludwig Herterich (1856–1932) in Munich. Here she is left to her own devices, experiences the free, carefree student life and forms friendships that will last a lifetime. She travels to Venice for ten days around Easter 1890, together with Beate Jeep (1865–1954) and Marianne Fiedler (1864–1904). Back in Königsberg, she rents a small studio and receives her first commissions.

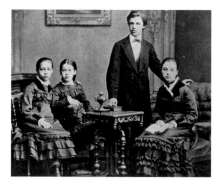

**37** The Schmidt children.
From left: Käthe, Lisbeth, Konrad
and Julie, ca. 1880

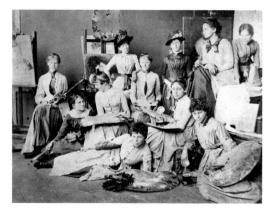

**38** Ludwig Herterich's
painting class at the
Munich School for Women
Artists, Käthe Kollwitz
seated, second from right,
1889

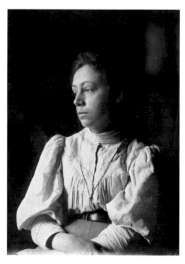

**39** Käthe Kollwitz, ca. 1890

**1891**   After marrying Karl Kollwitz, Käthe settles in Berlin. The young couple moves into an apartment on Weissenburger Strasse (today: Kollwitz-strasse) in the Prenzlauer Berg district, where Karl establishes his medical practice. There is no possibility of a studio of her own in Berlin, as there was in Königsberg. Käthe gives up the unwieldly format of large paintings in favour of graphic art. Her "living room studio" makes etching possible in a small space.

**1892**   Käthe Kollwitz's son Hans is born on 14 May.

**1893–1897**   Käthe Kollwitz's first works are exhibited in Berlin and re-viewed in publications. She finds an early advocate in the writer and art critic Julius Elias (1861–1927). Inspired by the première of Gerhart Hauptmann's drama *The Weavers*, she abandons the work she had begun on a series based on Émile Zola's *Germinal* and turns to the subject of the weavers, who, driven by hunger, rose in rebellion in 1844. Her first cycle, *A Weavers' Revolt*, is completed in time for the 70th birthday of her father, who dies soon after.

**1896**   Kollwitz's son Peter is born on 6 February.

**1898–1903**   At the Great Berlin Art Exhibition, Käthe Kollwitz achieves her artistic breakthrough with her cycle on *A Weavers' Revolt*. Max Lieber-mann (1847–1935), a member of the prize jury, recommends the young art-ist for an award, but this is rejected due to the veto of Kaiser Wilhelm II (1859–1941).
Max Lehrs (1855–1938) acquires works by the artist for the Dresden Kup-ferstich Kabinett (Graphic Arts Museum). He and Max Liebermann are Käthe Kollwitz's most important patrons during these years.
By participating in exhibitions outside Berlin and Germany, Kollwitz earns her first financial successes and her graphic works sell well. In 1901 she becomes a member of the newly founded Berlin Secession and of the As-sociation of Berlin Women Artists, where she teaches etching and drawing until 1903.

**1904**   After a first trip to Paris in 1901, Käthe Kollwitz attends the sculp-ture class at the Académie Julian for two months in 1904. She makes contact

with the sculptor Auguste Rodin (1840–1917) and is allowed to visit his studios in Paris and Meudon.

The etching *Charge* earns her the first prize in the competition held by the Association for Historical Art, which commissions a series of etchings under the title *Bauernkrieg* (Peasants' War) as an association gift until 1908. To this end, she continues her study of the historical events of 1524/1526, which she had begun in 1901.

**1907**   Käthe Kollwitz wins the Villa Romana Prize donated by Max Klinger for a one-year study trip to Florence, but uses the opportunity only for a brief visit. The highlight of her trip to Italy is a three-week hike from Florence to Rome in the company of the Englishwoman Constance 'Stan', Harding-Krayl (1884–?).

**1908–1913**   The *Peasants' War* cycle is printed in a large print run by Emil Richter Verlag Dresden. Until 1931 Richter has the sole rights for all the artist's prints. Käthe works for two years from 1908 as a freelancer for the satirical magazine *Simplicissimus*. Her works printed there mainly depict the misery and problems of the working class. In 1912, she addresses the housing shortage in the rapidly expanding city in the poster *'For Greater Berlin,'* which is banned by the authorities for 'inciting class struggle.'

In 1912, the artist moves into a sculptor's studio in the Künstlerhaus Siegmunds Hof and creates her first sculptural works. These include the small sculptures *Woman with Child in Lap* and *Lovers*, which she exhibits as her first sculptural work at the Free Secession exhibition in 1916.

**1914–1918**   On 1 August, Germany declares war on Russia, to the jubilation of large sections of the population. At the beginning of the First World War, the desire to volunteer for military service is high, and Käthe Kollwitz's sons Hans and Peter want to go to the front too. With the support of his mother, Peter, who is not yet of age for military service, convinces his father, who rejects the war, to agree. After a short period of instruction Peter is sent to the Belgian front and dies there in the night of 23 October 1914. The parents do not learn of his death until 30 October.

Käthe Kollwitz suffers profoundly under the loss of her son. It changes her view on war, making her a pacifist during the catastrophic course of the

conflict. She deals with her own pain artistically and plans to erect a memorial to honour the fallen war volunteers. At the end of October 1918, she resolutely opposes the appeal by the poet Richard Dehmel (1863–1920) for a last war draft in a public letter.

**1917**   A major solo exhibition on the occasion of Käthe Kollwitz's 50th birthday is held at Paul Cassirer Gallery and travels to Königsberg and Dresden, among other places. The artist exhibits for the first time a large number of drawings and successfully sells them to private collectors.

**1919–1926**   In 1919, Käthe Kollwitz is the first woman to become a full member of the Prussian Academy of Arts and is also appointed professor. She is involved in many campaigns against hunger, war and poverty and meets sympathisers including the physicist Albert Einstein (1879–1955) and the painter Otto Nagel (1894–1967), who is close to the KPD, the German communist party. Posters and commissioned works make up a large proportion of her artistic production. She works on a series on the war, but is dissatisfied with her etched and lithographed sketches. Inspired by the woodcuts of Ernst Barlach (1870–1938), she explores this new technique and completes the series *War* in seven woodcuts in 1922. Before that, in 1920, she creates her first woodcut *In Memoriam Karl Liebknecht*, in response to the assassination of the socialist Liebknecht (1871–1919) in January of the previous year.

In the summer of 1921 Käthe and Karl become grandparents. Their son Hans marries the young illustrator Ottilie Ehlers (1900–1963); they name their firstborn after his uncle Peter. In 1923 the twins Jutta and Jördis are born, followed by Arne Andreas in 1930.

In 1925, Käthe's mother Katharina Schmidt dies. She had lived in the Kollwitz family home since 1919.

**1927**   Numerous exhibitions are held to honour the artist's 60th birthday, including at the Prussian Academy of Arts, but also in New York, Switzerland and the Soviet Union. Käthe and Karl are invited to travel to Moscow for the celebrations of the 10th anniversary of the October Revolution.

**1928–1932**   Käthe Kollwitz takes over as head of the master studio for graphic arts at the Akademie der Künste. The teaching assignment also includes two studio rooms at the arts college in Hardenbergstrasse.

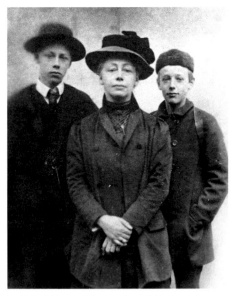

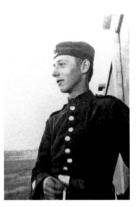

**40** Käthe Kollwitz with her sons Hans (left) and Peter (right), 1909

**41** Peter Kollwitz in uniform, autumn 1914

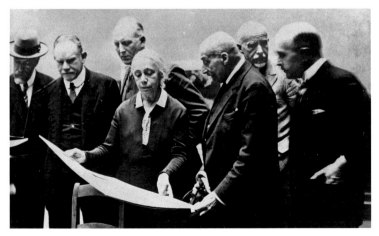

**42** Käthe Kollwitz (centre) and Max Liebermann (centre right) at the jury meeting for the Autumn Exhibition in the Akademie der Künste, 1927

In May 1929, she becomes the first woman to be awarded the medal 'Pour le mérite' for Science and the Arts.

In 1929, in memory of the recently deceased fellow artist Heinrich Zille (1858–1929), Kollwitz assumes patronage for the silent film *Mother Krausen's Trip to Happiness*, together with Otto Nagel and Hans Baluschek (1870–1935). A poster designed by her and one by Otto Nagel in the style of Heinrich Zille promote the film.

Since 1924 Käthe Kollwitz had been working on a new concept for her planned memorial for those who died in action. In 1931 she exhibits the plaster models of the *Grieving Parents* for the first time at the Academy Exhibition, and the following year the figures are carved out of Belgian granite and presented in the entrance hall of the National Gallery. Thanks to Albert Einstein's intercession with the Belgian queen, the memorial can be erected at the military cemetery in Roggevelde as early as July 1932, in the presence of Käthe and Karl Kollwitz; in 1957 it is transferred to Vladslo. At the end of July 1932 Germany is to elect a new Reichstag; the National Socialist party NSDAP threatens to become the strongest political force. In an 'Urgent Appeal,' Käthe and Karl Kollwitz, together with Albert Einstein, Heinrich Mann (1871–1950) and many other well-known figures, call for the SPD (socialist) and KPD (communist) parties to join forces as a 'united workers' front.' The appeal remains politically inconsequential.

**1933**   In February, the 'Urgent Appeal' calls once more for the unification of the left-wing parties against Hitler, and is again signed by Käthe and Karl together with Heinrich Mann and other personalities. Käthe Kollwitz and Heinrich Mann are then forced to resign from the Academy of Arts. Max Liebermann resigns as honorary president of the Academy in May and also leaves the Academy; he dies in 1935. Kollwitz is one of the few to attend his funeral procession.

Karl Kollwitz's health insurance licence is temporarily revoked, and his son Hans, by now a school doctor in Berlin, also briefly loses his job.

**1934–1937**   At the beginning of 1934, the artist has to leave her master studio at the Academy and in the autumn moves into new rooms in the Klosterstrasse studio community. There she finishes work on the large sculpture *Mother with Two Children* and has the group cast in cement and carved in shell limestone. The casting is to be presented for the first time

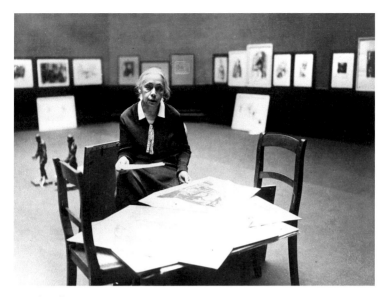

**43** Käthe Kollwitz selecting
her works in the Akademie der
Künste, 1927

**44** Käthe Kollwitz in her studio
in Klosterstrasse, ca. 1937

at an exhibition for her 70th birthday. Finding a venue for this exhibition becomes increasingly difficult. By 1935 her works are removed from some exhibitions, and in 1936 both sculptures submitted by Kollwitz for the anniversary show on Berlin sculptors in the Academy of Arts are removed at short notice. As part of the 'Degenerate Art' campaign confiscations in eleven German museums follow in 1937. Her birthday exhibition at the Buchholz Gallery is banned at the last minute, but is still accessible to insiders. Kollwitz finally presents the seven lithographs from the *Death* cycle, begun in 1934, in her studio.

**1936**   Due to an article in the Moscow daily newspaper *Izvestia* based on an interview with Käthe Kollwitz, the artist is interrogated by the Gestapo. She is threatened with imprisonment in a concentration camp if she should be called in again.
Kollwitz completes the bronze relief *Repose in the Peace of His Hands* for her family grave in the Berlin-Friedrichsfelde Central Cemetery.

**1938**   The artist is deeply moved by the death of Ernst Barlach on October 24. She sketches him on his deathbed and begins work on the bronze relief *Lamentation*, which she completes in 1941.
Increasing numbers of friends, colleagues and family members turn their backs on Nazi Germany. Käthe experiences the increasing persecution of Jews firsthand through the family of her sister Lisbeth Stern.

**1940**   Karl Kollwitz dies on 19 July. Käthe decides to give up her studio in the Klosterstrasse. Her health gradually deteriorates.

**1941-1945**   Titled with the quotation 'Seed for Sowing Should Not be Milled' from Goethe's *Wilhelm Meister*, she creates what is presumably her last lithograph as an artistic legacy in 1941. In the face of an impending world war, Käthe Kollwitz again launches her 1918 appeal against Richard Dehmel and the war.
In 1942, her grandson Peter dies in action on 22 September on the eastern front near Rzhev (Soviet Union).
In August 1943 the beginning of bombing raids on Berlin drives Käthe Kollwitz to leave her home. She moves in with the sculptor Margret Böning (1911–1995) in Nordhausen, Thuringia. Her artistic works are rescued

**45** Karl and Käthe Kollwitz, summer 1935

**46** Käthe and Karl with grandchildren, 1935

**47** Käthe with sister Lise (left)
in Nordhausen, 1943/44

before the house in Weissenburger Strasse is destroyed in November 1943. In 1944 Nordhausen is no longer safe either and Käthe Kollwitz finds refuge in Moritzburg near Dresden. At the invitation of Prince Ernst Heinrich of Saxony (1896–1971) she moves into two rooms in the Rüdenhof mansion, with granddaughter Jutta at her side. Käthe Kollwitz dies on 22 April, only days before the end of the war.

In September, the artist's urn is taken to Berlin and buried in the family grave.

**AFTER 1945**    The first Berlin exhibition commemorating Käthe Kollwitz is held from October to November 1945 at the Landwirtschaftliche Hochschule (Agricultural College) on behalf of the Magistrate of the City of Berlin. A Käthe Kollwitz memorial exhibition is also held almost simultaneously at the St. Etienne Gallery in New York, and in the summer of 1946 the Kunstmuseum Bern presents works by the artist.

After the end of the war and his early retirement, Hans Kollwitz (1892–1971) devotes himself entirely to his mother's artistic legacy and publishes the first excerpts from her diaries and letters in the late 1940s. In 1948, the book *60 Years of Friendship with Käthe Kollwitz* appears, in which Beate Bonus-Jeep – drawing on decades of correspondence with her friend – recounts Käthe Kollwitz's life and work. The painter Otto Nagel also dedicates a monograph to Käthe Kollwitz and works on a catalogue raisonné of her drawings, which is continued after his death by Werner Timm (1927–1999) and Nagel's daughter Sibylle (1943–2015), and finally published by the East German publisher Henschelverlag in 1972. In a divided Germany, Käthe Kollwitz receives honours from both sides on her 100th birthday. Numerous national and international special exhibitions commemorate her. But it is not until the 1980s that the Kollwitz family finds important supporters for the founding of a museum in honour of the artist. In 1985, the Käthe Kollwitz Museum opens in Cologne under the direction of granddaughter Jutta Bohnke-Kollwitz (1923–2021), and in 1986, the Käthe Kollwitz Museum is inaugurated in Berlin, thanks to a private initiative by art dealer and collector Hans Pels-Leusden (1908–1993).

# KÄTHE KOLLWITZ
## GEDÄCHTNIS = AUSSTELLUNG

In der Landwirtschaftlichen Hochschule

BERLIN N · Invalidenstraße 42

OKTOBER – NOVEMBER 1945 · TÄGLICH 10–17 UHR

Eintrittspreis 0.50 RM · Dauerkarte 1.50 RM

**48** Poster for the Käthe Kollwitz exhibition
in Berlin, autumn 1945

Cover of a field post letter to Peter Kollwitz, 25 October 1914

# ARCHIVE

---

Findings, Letters, Documents
1907–1937

I

I

*In 1906 Käthe Kollwitz was awarded the Villa Romana prize, which entitled her to accommodation at the eponymous artist residence in Florence and the use of a studio. From April to July 1907 she stayed in Italy, where she was visited by her sons and husband Karl. In the periods without her family Käthe often felt lonely. Florence did not inspire her artistically, so that she did not use the studio. In May 1907 she wrote her sister Lisbeth from Florence:*

Dear Lise – I would like to write you properly once again. Sometimes I'm homesick, for my people at home, but also for all of you. Especially now, when it is Hans' birthday, the tears flow all too easily. But this too will pass. [...] Since Peter left I have begun to really explore Florence. Finishing, however, is unthinkable. I think one could stay here for half a year and still not see everything that is worth seeing. [...]

Now the roses are blooming – but simply in masses. On the street you are offered roses for almost nothing. If you don't want them, the hawker says you should at least smell them, and walks beside you up the street, holding a bunch of them to your nose. Finally you have to laugh and he laughs too, and then you buy them. [...]

---

I Käthe Kollwitz to her sister Lise Stern, May 1907

**2**

2

*Like so many other young men, both of Kollwitz's sons wanted to go to the
front immediately after World War I broke out. Peter volunteered and after
just fourteen days of instruction was sent to the western front. Despite the
understanding that Käthe showed her sons for their enthusiasm for the war,
she was very fearful for their lives. Every day she wrote to the front. Letters
and postcards took a long time to reach their destination, however, so that
the Kollwitz family did not receive the news of Peter's death on 22 October
1914, until 30 October. On 25 October Käthe wrote him:*

My dear Peter! Today is Sunday and while we are sitting here around the
table, you might be fighting. The long-awaited first message from you ar-
rived yesterday, it brought us the confirmation of what we had expected,
that you all have been thrown directly into the fire. [...]
Farewell dear child – send us a message. Mother
Father always writes separately.
We think that you could have so little news that you will get more if we
write singly and more often. Are you cold?

---

**2** Käthe Kollwitz to her son Peter, 25 October 1914

**3**

*The poet Richard Dehmel (1863–1920) was renowned and highly respected around 1900 for his sensual love poetry, but after 1914 he infused his work with intense nationalistic pathos. He took part in the battles of World War I as a volunteer, calling for a renewed mobilisation of volunteers in October 1918 with the appeal 'The Only Salvation,' published in the newspaper* Vorwärts. *In response, Käthe Kollwitz wrote a dissenting reply that likewise appeared in* Vorwärts *on 28 October as well as in the* Vossische Zeitung *on 30 October. It ends with the words:*

Enough dying! No one must die anymore! I appeal against Richard Dehmel with the words of a greater one, who said: 'Seed for sowing should not be milled.'
Käthe Kollwitz

**3** 'To Richard Dehmel' from Käthe Kollwitz, published in *Vorwärts* on 28 October 1918, no. 297, vol. 35

**4** Gerhart Hauptmann to Käthe Kollwitz, apparently on her birthday 8 July 1932

*The graphic artist Käthe Kollwitz and the poet Gerhart Hauptmann had probably known each other since 1886, each valuing the work of the other. They corresponded for decades, but never crossed the boundary from the formal 'Sie' (you) to the informal 'Du' (thou). In 1924 Hauptmann wrote the foreword to the portfolio* Departure and Death, *which reproduced drawings by Käthe Kollwitz on the subject of death. Every year they sent each other birthday cards and New Years' wishes, which testify to their long acquaintance and mutual respect. Reproduced here is the draft for a letter by Hauptmann congratulating Kollwitz from 1932, which is preserved in the writer's estate.*

Käthe Kollwitz
Weissenburger Strasse 25, Berlin
In the heartfelt bond existing since our youth I congratulate today the great artist and the true human being, from the small island where I last had the pleasure of briefly seeing you.
May the spirit of profound humanity that infuses you and your works not perish and may you be granted all the happiness that your noble being deserves.
Sincerely, from house to house
Gerhart Hauptmann

*During the election campaign in July 1932 for the Reichstag (parliament) 33 leading personalities from the arts and science published an appeal for cooperation between the SPD (socialist) und KPD (communist) parties, in order to prevent the Nazi party from gaining more strength. This 'Urgent Appeal' was repeated and signed by 19 persons before the last elections to the Reichstag in March 1933. On both occasions Karl and Käthe Kollwitz numbered among the signatories.*

# Dringender Appell!

Die Vernichtung
aller persönlichen und politischen Freiheit

in Deutschland steht unmittelbar bevor, wenn es nicht in letzter
Minute gelingt, unbeschadet von Prinzipiengegensätzen alle Kräfte
zusammenzufassen, die in der Ablehnung des Faschismus einig
sind. Die nächste Gelegenheit dazu ist der 5. März. Es gilt, diese
Gelegenheit zu nutzen und endlich einen Schritt zu tun zum

Aufbau einer einheitlichen Arbeiterfront,

die nicht nur für die parlamentarische, sondern auch für die weitere
Abwehr notwendig sein wird. Wir richten an jeden, der diese
Überzeugung mit uns teilt, den dringenden Appell, zu helfen, daß

ein Zusammengehen der SPD
und KPD für diesen Wahlkampf

zustande kommt, am besten in der Form gemeinsamer Kandidaten-
listen, mindestens jedoch in der Form von Listenverbindung. Ins-
besondere in den großen Arbeiterorganisationen, nicht nur in den
Parteien, kommt es darauf an, hierzu allen erdenklichen Einfluß
aufzubieten. Sorgen wir dafür, daß nicht Trägheit der Natur
und Feigheit des Herzens uns in die Barbarei versinken lassen!

Willi Eichler, Karl Emonts, Hellmuth Falkenfeld, Kurt Großmann,
E. J. Gumbel, Theodor Hartwig, Maria Hodann, Käthe Kollwitz, Karl
Kollwitz, Robert Kuczynski, Otto Lehmann-Rußbüldt, Heinrich Mann,
Paul Oestreich, August Siemsen, Minna Specht, Erich Zeigner.

Setzt die Verantwortlichen unter Druck!

---

**5** 'Urgent Appeal', poster from 1933
**6** Leo von König to Käthe Kollwitz, 1 August 1936

**6**

*Due to her participation in the 'Urgent Appeal' Käthe Kollwitz was forced to leave the Akademie der Künste and give up her studios there. Despite these restrictions, Kollwitz was able to finish the large sculpture* Mother with Two Children *that was so important to her. But for cost reasons she was not able to transfer it to a permanent material. It was only the generous contribution from her fellow artist Leo von König (1871–1944) that allowed her to have the plaster model carved in stone:*

1st August, 36
Dear Madame!
Mr. Immanuel told me that you would like to execute a work in stone, but that unfortunately the money for this is not available.
I would like to sincerely ask you to accept this sum from me.
It would be a special pleasure for me to express my great admiration for you and your work in this manner.
I hope not to have made an unseeming request,
and greet you with enduring respect.
Your sincerely devoted,
Leo König

# SOURCES

Published by
Hirmer Verlag GmbH
Bayerstraße 57–59
80335 Munich
Germany

Cover: Käthe Kollwitz, *Self-Portrait towards left, with Neck,* 1902, crayon lithograph, © Käthe-Kollwitz-Museum Berlin
Double page 2/3: *Charge*, sheet 5 from the cycle *Peasants' War*, 1902/03 (detail), see p. 29
Double page 4/5: *March of the Weavers*, sheet 4 from the cycle *A Weavers' Revolt*, 1893–98 (detail), see p. 21

www.hirmerpublishers.com

With the kind support of

—
**TRANSLATION**
David Sánchez Cano, Madrid

—
**COPY-EDITING**
Jane Michael, Munich

—
**PROJECT MANAGEMENT**
Rainer Arnold, Gunnar Musan

—
**GRAPHIC DESIGN**
Marion Blomeyer, Rainald Schwarz, Munich

—
**LAYOUT AND PRODUCTION**
Marion Blomeyer, Munich

—
**PRE-PRESS AND REPRO**
Reproline mediateam GmbH, München

—
**PRINTING AND BINDING**
Grafisches Centrum Cuno GmbH & Co. KG, Calbe

Bibliographic information published by the Deutsche Nationalbibliothek
The Deutsche Nationalbibliothek lists this publication in the Deutsche Nationalbibliografie; detailed bibliographic data is available on the Internet at http://www.dnb.de.

ISBN 978-3-7774-4137-5
Printed in Germany

# ALREADY PUBLISHED

MAX BECKMANN
978-3-7774-4282-2

HEINRICH CAMPENDONK
978-3-7774-4084-2

PAUL CÉZANNE
978-3-7774-3813-9

WILLEM DE KOONING
978-3-7774-3073-7

LYONEL FEININGER
978-3-7774-2974-8

CONRAD FELIXMÜLLER
978-3-7774-3824-5

PAUL GAUGUIN
978-3-7774-2854-3

RICHARD GERSTL
978-3-7774-2622-8

JOHANNES ITTEN
978-3-7774-3172-7

FRIDA KAHLO
978-3-7774-4138-2

VASILY KANDINSKY
978-3-7774-2759-1

ERNST LUDWIG KIRCHNER
978-3-7774-2958-8

GUSTAV KLIMT
978-3-7774-3979-2

KÄTHE KOLLWITZ
978-3-7774-4137-5

HENRI MATISSE
978-3-7774-2848-2

PAULA MODERSOHN-BECKER
978-3-7774-3489-6

LÁSZLÓ MOHOLY-NAGY
978-3-7774-3403-2

KOLOMAN MOSER
978-3-7774-3072-0

ALFONS MUCHA
978-3-7774-3488-9

EMIL NOLDE
978-3-7774-2774-4

AGNES PELTON
978-3-7774-3929-7

PABLO PICASSO
978-3-7774-2757-7

HANS PURRMANN
978-3-7774-3679-1

EGON SCHIELE
978-3-7774-2852-9

FLORINE STETTHEIMER
978-3-7774-3632-6

VINCENT VAN GOGH
978-3-7774-2758-4

MARIANNE VON WEREFKIN
978-3-7774-3306-6

www.hirmerpublishers.com